CW00495665

Amanda Frances Inc.
www.amandafrances.com

Rich as F*ck Planner / Amanda Frances - 1st ed.

ISBN: 978-1-7353751-8-2 (paperback)

Welcome to the Best Year of Your... Life!

I am so over-the-moon-jazzed-as-all-get-out to welcome you to the Rich as F*ck Planner. It is my intention that this planner support you in creating your best days, weeks, months, and years... ever.

Now, as you may have gathered, this isn't your regular planner. It was made to support you in manifesting, calling in, and creating your ideal life — with every single thing you want inside of it.

Because, duh. That's what we do.

And please note: You do not have to start this planner at the beginning of the year! Every day is a great day to begin again and every day is a great day to pick up this planner and start to fill it in, letting it support you as you go.

As you begin to dig into these pages, I encourage you to open your heart, get shockingly honest with yourself, and trust the guidance that shows up. (Remember: It is safe to trust yourself.)

Team AF and I have poured a whole hell of a lot of love into this planner and I truly cannot wait to see what you create today, this week, this month, and this year with the Rich as F*ck Planner by your side.

Please write me (support@amandafrances.com) and tag me on the social medias (@xoamandafrances) as you make your way through these pages. I can't wait to learn how it has served you.

all the love.

Amanda
FRANCES ♕

HOW TO USE THE RICH AS F*CK PLANNER

If you are here, it is likely that you have read the international best-selling book, Rich as F*ck. Like the book, this planner is meant to help you unlock desire, remember your power, see limitless possibilities, and realize your dreams.

You'll find that the planner was designed, very intentionally. At the start of this journal, and every four weeks thereafter, you will notice a large full-page affirmation. On the opposite page you will find journal prompts and reflection questions, to help you integrate that month's idea into your conscious and subconscious mind, and into your life.

Next, you will find the week at a glance, followed by a weekly a section to declare what you are calling in (everything you are intentionally manifesting) as well as a place to note all you are grateful for (as you know, this will speed up the manifestation process) and what you are releasing (what you are ready to let go of and what no longer serves you).

Inside each week at a glance, you will find a weekly affirmation along with space to write it in your own handwriting (a power move for your subconscious), a moment to celebrate yourself (Ways I Crushed it This Week), and a place to lock-in your desires for the week.

If you have not read the Rich as F*ck book, now would be the perfect time to do so. The concepts in the book will bring the quotes, affirmations, and prompts in this planner to life — multiplying and magnifying your results. (If you have read the book and are wondering what may be the next right step for you, consider the world-renowned digital course, Money Mentality Makeover.)

To utilize this planner to its absolute fullest, be sure to really delve into the ideas, beliefs and principles presented to you here. Think on them, ponder them, notice where they feel true to you and where you feel resistance to them (use the Rich as F*ck book to work through any resistance as needed). And — just as with the book — don't skip the homework. Each question and journal prompt presented to you here is meant to help you to embrace a concept needed to create and allow in all you want in this life.

So dig in, get honest, let this planner support you and get ready for your best year ever — mother fucking ever!

Let's go...

AS I BEGIN MY JOURNEY WITH THE RICH AS F*CK
PLANNER, I CHOOSE AND DECLARE THE
FOLLOWING FOR MY LIFE:

I will be better with money,
Not Waste, ajuse + Save money
towards: Income improvement,
Holidays,

I KNOW I AM WORTHY OF THIS.
I KNOW IT IS MEANT TO BE MINE.

I HAVE THE DIVINE RIGHT TO DESIGN MY LIFE AS I SEE FIT.

@xoamandafrances

You are the creator of your life and world. This does not mean we are unaware or unaffected by outside circumstances, it means we know our power — our massive co-creative power. Let's dig into this.

If you were a powerful creator with the magnificence of the divine living within you and you had the divine right to change, transform, transmute, transfigure, and design your life… what would this mean for you?

Better relationship with money.

What areas would need to be reworked and rearranged in your favor?

Past issues.

What would you let yourself want? Perhaps something you haven't been honest with yourself about (until now)? _Better Money relationship organized home._

Say it with me: I have the divine right to design my life as I see fit.

Week of _3_ / _6_ / _2024_

My desire for the week:

To Save money,

Monday:

Tuesday:

Wednesday:

Thursday:

This week's affirmation:

Money loves me.

Now, you write it:

Friday:

Saturday:

Sunday:

Ways I crushed it this week:

Week of ___/___/___

Things to do / Things to remember:

Things I'm releasing:

Things I'm calling in:

What I am grateful for:

Week of ___/___/___

My desire for the week:

Monday:

Tuesday:

Wednesday:

Thursday:

This week's affirmation:

Money was made to support me.

Now, you write it:

Friday:

Saturday:

Sunday:

Ways I crushed it this week:

Week of ___/___/___

Things to do / Things to remember:

Things I'm releasing:

Things I'm calling in:

What I am grateful for:

Week of ___/___/___

My desire for the week:

Monday:

Tuesday:

Wednesday:

Thursday:

This week's affirmation:

Good people do good things with money. (And I am good people.)

Now, you write it:

Friday:

Saturday:

Sunday:

Ways I crushed it this week:

Week of ___/___/___

Things to do / Things to remember:

Things I'm releasing:

Things I'm calling in:

What I am grateful for:

Week of ___/___/___

My desire for the week:

Monday:

Tuesday:

Wednesday:

Thursday:

This week's affirmation:

I allow money in – in increasing quantities – all of the time. Forever and ever.

Now, you write it:

Friday:

Saturday:

Sunday:

Ways I crushed it this week:

Week of ___/___/___

Things to do / Things to remember:

Things I'm releasing:

Things I'm calling in:

What I am grateful for:

SAY IT WITH ME:

I AM ABOUT TO RECEIVE MORE MONEY THAN I COULD **EVER** IMAGINE.

@xoamandafrances

This is one of my all time favorite affirmations. I was visiting NYC, early in my business, working from my laptop when it floated across my mind. To me this affirmation feels full of endless possibility, confident anticipation, and certainty that good things are on the way.

How does this affirmation feel in your body? If it feels exciting, expansive or opening, we are on the right track. If it feels impossible or untrue, please begin to tweak it until you land on something that feels more real for you, but is still in a direction you desire to go.

So, tell me, my love: If you were about to receive more money than you could ever imagine, how would that feel?

If you were about to receive more money than you could ever imagine, what would you know?

If you were about to receive more money than you could ever imagine, what would you release? What worries would you leave behind? What would shift for you?

Say it with me: I am about to receive more money than I could ever imagine.

Week of ___/___/___

My desire for the week:

Monday:

Tuesday:

Wednesday:

Thursday:

This week's affirmation:

My desires are guiding me. I am worthy of everything I desire.

Now, you write it:

Friday:

Saturday:

Sunday:

Ways I crushed it this week:

Week of ___/___/___

Things to do / Things to remember:

Things I'm releasing:

Things I'm calling in:

What I am grateful for:

Week of ___/___/___

My desire for the week:

Monday:

Tuesday:

Wednesday:

Thursday:

This week's affirmation:

I am always being guided.

Now, you write it:

Friday:

Saturday:

Sunday:

Ways I crushed it this week:

Week of ___/___/___

Things to do / Things to remember:

Things I'm releasing:

Things I'm calling in:

What I am grateful for:

Week of ___/___/___

My desire for the week:

Monday:

Tuesday:

Wednesday:

Thursday:

This week's affirmation:

My work is of high service and worthy of massive compensation.

Now, you write it:

Friday:

Saturday:

Sunday:

Ways I crushed it this week:

Week of ___/___/___

Things to do / Things to remember:

Things I'm releasing:

Things I'm calling in:

What I am grateful for:

Week of ___/___/___

My desire for the week:

Monday:

Tuesday:

Wednesday:

Thursday:

This week's affirmation:

I am loved, appreciated, and supported by money.

Now, you write it:

Friday:

Saturday:

Sunday:

Ways I crushed it this week:

Week of ___/___/___

Things to do / Things to remember:

Things I'm releasing:

Things I'm calling in:

What I am grateful for:

SAY IT WITH ME:

THE MORE I AM

SUPPORTED BY

money, THE

MORE *good*

I CAN DO.

- Amanda Frances

A lot of us still feel selfish for wanting... more.

A practice I have is regularly looking at and evaluating how my abundance is beneficial to those around me and to the outside world. Let's dig in.

As you are financially abundant, supported and blessed, how does this benefit your life? (Example: Stress around bills decreased.)

As you are financially abundant, supported and blessed, how does this positively impact your family and friends? (Example: Buying lunch for friends. Paying for children's activities.)

As you are financially abundant, supported and blessed, how does this positively impact your community and the outside your world? (Example: Donations you make.)

Say it with me: The more I am supported by money, the more good I can do.

Week of ___/___/___

My desire for the week:

Monday:

Tuesday:

Wednesday:

Thursday:

This week's affirmation:

What I need is given to me. What does not serve me is removed.

Now, you write it:

Friday:

Saturday:

Sunday:

Ways I crushed it this week:

Week of ___/___/___

Things to do / Things to remember:

Things I'm releasing:

Things I'm calling in:

What I am grateful for:

Week of ___/___/___

My desire for the week:

Monday:

Tuesday:

Wednesday:

Thursday:

This week's affirmation:

I am enough. I live a life of more than enough.

Now, you write it:

Friday:

Saturday:

Sunday:

Ways I crushed it this week:

Week of ___/___/___

Things to do / Things to remember:

Things I'm releasing:

Things I'm calling in:

What I am grateful for:

Week of ___/___/___

My desire for the week:

Monday:

Tuesday:

Wednesday:

Thursday:

This week's affirmation:

Impossible goals are more fun. I delight in going after what would be impossible for most, but is inevitable for me.

Now, you write it:

Friday:

Saturday:

Sunday:

Ways I crushed it this week:

Week of ___/___/___

Things to do / Things to remember:

Things I'm releasing:

Things I'm calling in:

What I am grateful for:

Week of ___/___/___

My desire for the week:

Monday:

Tuesday:

Wednesday:

Thursday:

This week's affirmation:

God loves me. Life loves me. Money loves me.

Now, you write it:

Friday:

Saturday:

Sunday:

Ways I crushed it this week:

Week of ___/___/___

Things to do / Things to remember:

Things I'm releasing:

Things I'm calling in:

What I am grateful for:

I KNOW **WHO** I AM.

I KNOW **WHERE** I AM GOING.

NO MATTER WHAT OCCURS, I'VE GOT ME.

@xoamandafrances

I've realized this, the more uncertain we are about our own ability to take care of ourselves, the more anxiety we hold in our minds and bodies. However, when we know who we are, what we want and where we are going, we are stabilized by our own clarity and confidence.

If you knew you truly had your own back and would show up for yourself no matter what, how would that feel?

If you knew that your heart-felt desires were reliable guidance and it were safe to follow your heart, how would that feel? What would you let yourself want? What would you let yourself work toward? (PS: If you feel like you don't know, just answer the question as though you did know. ie: Pretend like you know and see what comes through.)

If who you were, what you want and where you were going were inevitable — and you knew you'd support yourself through it all — how would that feel? What would that mean for you? What would that mean about your future?

Say it with me: I know who I am. I know where I am going. No matter what occurs, I've got me.

Week of ___/___/___

My desire for the week:

Monday:

Tuesday:

Wednesday:

Thursday:

This week's affirmation:

I am co-creating the life of my dreams.

Now, you write it:

Friday:

Saturday:

Sunday:

Ways I crushed it this week:

Week of ___/___/___

Things to do / Things to remember:

Things I'm releasing:

Things I'm calling in:

What I am grateful for:

Week of ___/___/___

My desire for the week:

Monday:

Tuesday:

Wednesday:

Thursday:

This week's affirmation:

My next surprise infusion of money is as close as my next breath.

Now, you write it:

Friday:

Saturday:

Sunday:

Ways I crushed it this week:

Week of ___/___/___

Things to do / Things to remember:

Things I'm releasing:

Things I'm calling in:

What I am grateful for:

Week of ___/___/___

My desire for the week:

Monday:

Tuesday:

Wednesday:

Thursday:

This week's affirmation:

Money flows freely to me and through me. It is safe to circulate money and to enjoy money now.

Now, you write it:

Friday:

Saturday:

Sunday:

Ways I crushed it this week:

Week of ___/___/___

Things to do / Things to remember:

Things I'm releasing:

Things I'm calling in:

What I am grateful for:

Week of ___/___/___

My desire for the week:

Monday:

Tuesday:

Wednesday:

Thursday:

This week's affirmation:

Unlimited wealth and abundance are available to me now. I welcome the never-ending flow.

Now, you write it:

Friday:

Saturday:

Sunday:

Ways I crushed it this week:

Week of ___/___/___

Things to do / Things to remember:

Things I'm releasing:

Things I'm calling in:

What I am grateful for:

SAY IT WITH ME:

every

decision was

the right

decision

because it

all got me

here.

-Amanda Frances

Here is what we have to know for this affirmation to work for us: Where you are right now is divine. It's aligned. It is the perfect jumping off point for where you are going. I know it doesn't feel like it when we are in the middle of bullshit, but I promise you, where you are is a perfect place from which you will defy all odds and achieve your dreams. How does this land for you?

So, if where you are right now is an okay — or even divine — place to be, it is safe to release ourselves from everything that occurred up until now. It's time to forgive yourself. What are you still judging yourself for? What are you resenting yourself for?

It's imperative that we get you on the same page with yourself — where there is no resentment or bitterness. You will need you to get everywhere you are going in life. You will need to stop fighting yourself and get in line with yourself. Every past decision must be forgiven. Every "mistake" must be viewed as a part of the journey. Every misstep must be viewed as a required lesson. How does it feel to begin to let yourself off the hook?

Say it with me: Every decision was the right decision because it got me here.

Week of ___/___/___

My desire for the week:

Monday:

Tuesday:

Wednesday:

Thursday:

This week's affirmation:

Avalanches of money follow me and flow to me, everywhere I go.

Now, you write it:

Friday:

Saturday:

Sunday:

Ways I crushed it this week:

Week of ___/___/___

Things to do / Things to remember:

Things I'm releasing:

Things I'm calling in:

What I am grateful for:

Week of ___/___/___

My desire for the week:

Monday:

Tuesday:

Wednesday:

Thursday:

This week's affirmation:

It is all for my good and in my favor. It is all to my advantage. Always.

Now, you write it:

Friday:

Saturday:

Sunday:

Ways I crushed it this week:

Week of ___/___/___

Things to do / Things to remember:

Things I'm releasing:

Things I'm calling in:

What I am grateful for:

Week of ___/___/___

My desire for the week:

Monday:

Tuesday:

Wednesday:

Thursday:

This week's affirmation:

There is no other shoe to drop. It is safe to grow, earn, and receive in a truly massive way.

Now, you write it:

Friday:

Saturday:

Sunday:

Ways I crushed it this week:

Week of ___/___/___

Things to do / Things to remember:

Things I'm releasing:

Things I'm calling in:

What I am grateful for:

Week of ___/___/___

My desire for the week:

Monday:

Tuesday:

Wednesday:

Thursday:

This week's affirmation:

My heart is always right, and my time is always now.

Now, you write it:

Friday:

Saturday:

Sunday:

Ways I crushed it this week:

Week of ___/___/___

Things to do / Things to remember:

Things I'm releasing:

Things I'm calling in:

What I am grateful for:

I AM
SUPPORTED
IN DOING
MEANINGFUL
WORK I **LOVE**.

@xoamandafrances

Now, I know not everyone's desire in life is to do work they truly love and be handsomely paid for it, but this is most certainly my life purpose and mission rolled into one. This is how I believe it was meant to be for me, and for you too, if it's what you want.

So, if you were made to be paid for your gifts, skills, insights, wisdom, stories (or whatever the fuck you want to be paid for)... how would that feel to you? What would this mean for you?

If you were made to be paid for work you love, how would you approach your work, your craft, your occupation, your career or your current day job? Perhaps this belief changes how you approach entrepreneurship, the corporate work, and/or your daily tasks inside your current role or job?

If you were made to be paid for work you love, what would you work on today, this week, this month, and this year? What would you know? What would you choose? What would you believe? What would you go after?

Say it with me: I am supported in doing meaningful work I love.

Week of ___/___/___

My desire for the week:

Monday:

Tuesday:

Wednesday:

Thursday:

This week's affirmation:

I receive money with ease. I release money with ease. I save money with ease. I spend money with ease.

Now, you write it:

Friday:

Saturday:

Sunday:

Ways I crushed it this week:

Week of ___/___/___

Things to do / Things to remember:

Things I'm releasing:

Things I'm calling in:

What I am grateful for:

Week of ___/___/___

My desire for the week:

Monday:

Tuesday:

Wednesday:

Thursday:

This week's affirmation:

Money is safe with me. I am safe with money.

Now, you write it:

Friday:

Saturday:

Sunday:

Ways I crushed it this week:

Week of ___/___/___

Things to do / Things to remember:

Things I'm releasing:

Things I'm calling in:

What I am grateful for:

Week of ___/___/___

My desire for the week:

Monday:

Tuesday:

Wednesday:

Thursday:

This week's affirmation:

*Money is reliable. Money is a constant. Money just *is* in my life.*

Now, you write it:

Friday:

Saturday:

Sunday:

Ways I crushed it this week:

Week of ___/___/___

Things to do / Things to remember:

Things I'm releasing:

Things I'm calling in:

What I am grateful for:

Week of ___/___/___

My desire for the week:

Monday:

Tuesday:

Wednesday:

Thursday:

This week's affirmation:

Regardless of what is occurring the outside world, I am capable of making money. Nothing can stop me. Nothing can slow me down.

Now, you write it:

Friday:

Saturday:

Sunday:

Ways I crushed it this week:

Week of ___/___/___

Things to do / Things to remember:

Things I'm releasing:

Things I'm calling in:

What I am grateful for:

SAY IT WITH ME:

CREATIVE
IDEAS FOR
INFINITE
ABUNDANCE
ARE ALWAYS
COMING TO ME.

- Amanda Frances

Money is out there. It is circulating the planet, all of the time. People are releasing it (spending, donating, giving, using) and receiving it (generating, making, earning, allowing it in) every moment of every day. And hear me on this: You are capable of getting more of it to you. It is out there. It is available. It is for you. I'll say it again: Money is for you. From the place of knowing all of this is true, let's ponder this: Creative ideas for the creating, generation and receiving of money are always available to you.

If you were to view money as limitless, view yourself as infinitely capable of receiving, and know that there were a bajillion ways for money to come to you, what would that mean for you?

If you knew idea and opportunities for letting more money in were readily and wildly available, what would that mean for you?

I'd like you to take a moment to intentionally open up to this idea. Money is available. Ideas and opportunities for generating it are available. It's all available. And you are so worthy. (Your worth is not in question, ps. You were made worthy.) With all of that in mind, what do you choose to now know?

Say it with me: Creative ideas for infinite abundance are always coming to me.

Week of ___/___/___

My desire for the week:

Monday:

Tuesday:

Wednesday:

Thursday:

This week's affirmation:

Money loves to work with me. Money is my friend, my advocate, & my ally. Money is always by my side.

Now, you write it:

Friday:

Saturday:

Sunday:

Ways I crushed it this week:

Week of ___/___/___

Things to do / Things to remember:

Things I'm releasing:

Things I'm calling in:

What I am grateful for:

Week of ___/___/___

My desire for the week:

Monday:

Tuesday:

Wednesday:

Thursday:

This week's affirmation:

Money is available to me and on its way to me.

Now, you write it:

Friday:

Saturday:

Sunday:

Ways I crushed it this week:

Week of ___/___/___

Things to do / Things to remember:

Things I'm releasing:

Things I'm calling in:

What I am grateful for:

Week of ___/___/___

My desire for the week:

Monday:

Tuesday:

Wednesday:

Thursday:

This week's affirmation:

From this moment forward, my finances thrive in unprecedented and unmeasurable ways.

Now, you write it:

Friday:

Saturday:

Sunday:

Ways I crushed it this week:

Week of ___/___/___

Things to do / Things to remember:

Things I'm releasing:

Things I'm calling in:

What I am grateful for:

Week of ___/___/___

My desire for the week:

Monday:

Tuesday:

Wednesday:

Thursday:

This week's affirmation:

I am powerful. I am capable. I am worthy.

Now, you write it:

Friday:

Saturday:

Sunday:

Ways I crushed it this week:

Week of ___/___/___

Things to do / Things to remember:

Things I'm releasing:

Things I'm calling in:

What I am grateful for:

I WAS MADE TO MAKE MASSIVE MONEY.
I WAS MADE TO MAKE MASSIVE MONEY.
I WAS MADE TO MAKE MASSIVE MONEY.
I WAS MADE TO MAKE MASSIVE MONEY.
I WAS MADE TO MAKE MASSIVE MONEY.
I WAS MADE TO MAKE MASSIVE MONEY.
I WAS MADE TO MAKE MASSIVE MONEY.
I WAS MADE TO MAKE MASSIVE MONEY.
I WAS MADE TO MAKE MASSIVE MONEY.

I WAS MADE TO MAKE MASSIVE MONEY.

I WAS MADE TO MAKE MASSIVE MONEY.
I WAS MADE TO MAKE MASSIVE MONEY.
I WAS MADE TO MAKE MASSIVE MONEY.
I WAS MADE TO MAKE MASSIVE MONEY.
I WAS MADE TO MAKE MASSIVE MONEY.
I WAS MADE TO MAKE MASSIVE MONEY.
I WAS MADE TO MAKE MASSIVE MONEY.
I WAS MADE TO MAKE MASSIVE MONEY.
I WAS MADE TO MAKE MASSIVE MONEY.

@xoamandafrances

I have decided and I believe this for myself: I was made to be someone who makes money and generates wealth. (And I don't exactly believe that this was written in the stars before the beginning of time. In many ways, I feel I chose this and continue to choose it.)

Viewing my life this way affects my identity. I identify as someone who was made to make massive money. Having this in my identity, allows me to embody it, expect it, and realign to it when I begin to feel… off.

Ponder this: If you are a money-maker. If this is simply who you are and what you do, what would this mean for you?

If making massive money could be a natural extension of everything you do, what would you believe about your business or career? What would you expect and go after in life?

If you could begin to integrate in and identify with another quality that would serve or benefit you in your life, goals, desires, and mission — who would you want to be? Remember: It's all possible and available for you.

Say it with me: I am supported in doing meaningful work I love.

Week of ___/___/___

My desire for the week:

Monday:

Tuesday:

Wednesday:

Thursday:

This week's affirmation:

I trust myself to earn and receive money I trust myself to have money. I trust myself to do good shit with money.

Now, you write it:

Friday:

Saturday:

Sunday:

Ways I crushed it this week:

Week of ___/___/___

Things to do / Things to remember:

Things I'm releasing:

Things I'm calling in:

What I am grateful for:

Week of ___/___/___

My desire for the week:

Monday:

Tuesday:

Wednesday:

Thursday:

This week's affirmation:

Money was made for me.

Now, you write it:

Friday:

Saturday:

Sunday:

Ways I crushed it this week:

Week of ___/___/___

Things to do / Things to remember:

Things I'm releasing:

Things I'm calling in:

What I am grateful for:

Week of ___/___/___

My desire for the week:

Monday:

Tuesday:

Wednesday:

Thursday:

This week's affirmation:

As I slow down, so does time. Time is always on my side.

Now, you write it:

Friday:

Saturday:

Sunday:

Ways I crushed it this week:

Week of ___/___/___

Things to do / Things to remember:

Things I'm releasing:

Things I'm calling in:

What I am grateful for:

Week of ___/___/___

My desire for the week:

Monday:

Tuesday:

Wednesday:

Thursday:

This week's affirmation:

It is safe to create, innovate, and try new things. It is safe to evolve.

Now, you write it:

Friday:

Saturday:

Sunday:

Ways I crushed it this week:

Week of ___/___/___

Things to do / Things to remember:

Things I'm releasing:

Things I'm calling in:

What I am grateful for:

MONEY IS NOT
JUDGING ME;
MONEY IS
RESPONDING
TO ME.

- Amanda Frances

For all of us who didn't grow up with extra moola and monetary abundance, especially if we continually faced financial struggle, it can feel like money simply doesn't like us, doesn't want to work with us, and is not for people like us. It can feel like money is... judging us.

Here is the shift I had to make a long time ago: Money is not judging me; it is responding to me. I now know money simply responds to my thoughts, feelings, and dominant vibration concerning it and my money-making endeavors. It's my job to work through any conflicts or fears surrounding money. (For help with this, please see my book, *Rich as F*ck*.) When I am in an authentic, clean & clear place with money, it can flow naturally and easily.

If you were a more powerful force than money, and money had to follow your lead, what would this mean for you?

If money had to fulfill the roles, job, and position you give to it, what would that mean to you? If money had to come when you said for it to come, what would that mean for you?

If money were made to be in service to you, what would that mean for you?

Say it with me: Money is not judging me; Money is responding to me.

Week of ___/___/___

My desire for the week:

Monday:

Tuesday:

Wednesday:

Thursday:

This week's affirmation:

I trust myself.

Now, you write it:

Friday:

Saturday:

Sunday:

Ways I crushed it this week:

Week of ___/___/___

Things to do / Things to remember:

Things I'm releasing:

Things I'm calling in:

What I am grateful for:

Week of ___/___/___

My desire for the week:

Monday:

Tuesday:

Wednesday:

Thursday:

This week's affirmation:

I allow in more than enough. I live in overflow. I have more money than I even know what to do with.

Now, you write it:

Friday:

Saturday:

Sunday:

Ways I crushed it this week:

Week of ___/___/___

Things to do / Things to remember:

Things I'm releasing:

Things I'm calling in:

What I am grateful for:

Week of ___/___/___

My desire for the week:

Monday:

Tuesday:

Wednesday:

Thursday:

This week's affirmation:

I love how money amplifies me. It only accentuates my deeply loving & incredibly generous nature.

Now, you write it:

Friday:

Saturday:

Sunday:

Ways I crushed it this week:

Week of ___/___/___

Things to do / Things to remember:

Things I'm releasing:

Things I'm calling in:

What I am grateful for:

Week of ___/___/___

My desire for the week:

Monday:

Tuesday:

Wednesday:

Thursday:

This week's affirmation:

I attract the most incredible people into my life.

Now, you write it:

Friday:

Saturday:

Sunday:

Ways I crushed it this week:

Week of ___/___/___

Things to do / Things to remember:

Things I'm releasing:

Things I'm calling in:

What I am grateful for:

SAY IT WITH ME:

every move I make, makes me money.

— Amanda Frances

What if everything that occurred in your life contributed to your overall wealth & abundance? Of course, in many circumstances, I cannot see how what I am going through could possibly be to my benefit, much less increase my net worth, but I know this: It's all for my good. It's all in my favor. Time & time again, I discover this to be true.

If everything that occurred in your life was being used for your ultimate good, what would that mean for you? (I'm not even saying the shitty things had to happen the way they did. I am saying that once it is happening or after the shitty thing has occurred, it will end up being in your favor.) What would that change for you? How would you be seeing things differently now?

If you knew you that it were always possible to turn shit into gold — and that you were supported in doing this — how would you approach things differently?

If you were to begin to think of yourself as someone who generates wealth as a natural extension of existing, what would that mean for you? How would you feel now? How would you see things now?

Say it with me: Every move I make, makes me money.

Week of ___/___/___

My desire for the week:

Monday:

Tuesday:

Wednesday:

Thursday:

This week's affirmation:

Money is meant to flow. It is meant to be released & received. It naturally replenishes itself for me.

Now, you write it:

Friday:

Saturday:

Sunday:

Ways I crushed it this week:

Week of ___/___/___

Things to do / Things to remember:

Things I'm releasing:

Things I'm calling in:

What I am grateful for:

Week of ___/___/___

My desire for the week:

Monday:

Tuesday:

Wednesday:

Thursday:

This week's affirmation:

When I feel off, I know this: I can realign. I can re-decide. I can step back on to the foundation I have created and allow it to become more solid over time.

Now, you write it:

Friday:

Saturday:

Sunday:

Ways I crushed it this week:

Week of ___/___/___

Things to do / Things to remember:

Things I'm releasing:

Things I'm calling in:

What I am grateful for:

Week of ___/___/___

My desire for the week:

Monday:

Tuesday:

Wednesday:

Thursday:

This week's affirmation:

Everything is progress. Everything is forward motion. Each thing contributes to the next thing being possible for me.

Now, you write it:

Friday:

Saturday:

Sunday:

Ways I crushed it this week:

Week of ___/___/___

Things to do / Things to remember:

Things I'm releasing:

Things I'm calling in:

What I am grateful for:

Week of ___/___/___

My desire for the week:

Monday:

Tuesday:

Wednesday:

Thursday:

This week's affirmation:

I am growing. I am expanding. I am going bigger.

Now, you write it:

Friday:

Saturday:

Sunday:

Ways I crushed it this week:

Week of ___/___/___

Things to do / Things to remember:

Things I'm releasing:

Things I'm calling in:

What I am grateful for:

I AM THE EXCEPTION TO THE RULE.
I AM THE EXCEPTION TO THE RULE.
I AM THE EXCEPTION TO THE RULE.
I AM THE EXCEPTION TO THE RULE.
I AM THE EXCEPTION TO THE RULE.
I AM THE EXCEPTION TO THE RULE.
I AM THE EXCEPTION TO THE RULE.
I AM THE EXCEPTION TO THE RULE.
I AM THE EXCEPTION TO THE RULE.

I AM THE EXCEPTION TO THE RULE.

I AM THE EXCEPTION TO THE RULE.
I AM THE EXCEPTION TO THE RULE.
I AM THE EXCEPTION TO THE RULE.
I AM THE EXCEPTION TO THE RULE.
I AM THE EXCEPTION TO THE RULE.
I AM THE EXCEPTION TO THE RULE.
I AM THE EXCEPTION TO THE RULE.
I AM THE EXCEPTION TO THE RULE.

@xoamandafrances

This is a belief that has really served me. When it has seemed like where I come from, the path I'm on, the situation I find myself in, or the circumstance I am facing — from a very practical sense — will not create the result I want: I am the exception to the rule.

It doesn't matter how it has gone for other people from your town, in your industry, in your family, or who faced what you face — none of that has anything to do with you. You are the exception to the rule. It's going how you choose it to. Period.

If you were the exception to the rule, paving a completely different path for yourself than those who can before you, how would you feel?

If you were the exception to the rule, and how things appeared to be was irrelevant, what would you know?

If you were the exception to the rule, and how things had gone for other people had nothing to do with you, what would you expect?

Say it with me: Every move I make, makes me money.

Week of ___/___/___

My desire for the week:

Monday:

Tuesday:

Wednesday:

Thursday:

This week's affirmation:

I am unstoppable. I am always going after all I want.

Now, you write it:

Friday:

Saturday:

Sunday:

Ways I crushed it this week:

Week of ___/___/___

Things to do / Things to remember:

Things I'm releasing:

Things I'm calling in:

What I am grateful for:

Week of ___/___/___

My desire for the week:

Monday:

Tuesday:

Wednesday:

Thursday:

This week's affirmation:

The next level (of whatever I desire) is always available to me.

Now, you write it:

Friday:

Saturday:

Sunday:

Ways I crushed it this week:

Week of ___/___/___

Things to do / Things to remember:

Things I'm releasing:

Things I'm calling in:

What I am grateful for:

Week of ___/___/___

My desire for the week:

Monday:

Tuesday:

Wednesday:

Thursday:

This week's affirmation:

I am the best. I expect the best. I receive the best.

Now, you write it:

Friday:

Saturday:

Sunday:

Ways I crushed it this week:

Week of ___/___/___

Things to do / Things to remember:

Things I'm releasing:

Things I'm calling in:

What I am grateful for:

Week of ___/___/___

My desire for the week:

Monday:

Tuesday:

Wednesday:

Thursday:

This week's affirmation:

As I make space for what I need, more space is made for everything else.

Now, you write it:

Friday:

Saturday:

Sunday:

Ways I crushed it this week:

Week of ___/___/___

Things to do / Things to remember:

Things I'm releasing:

Things I'm calling in:

What I am grateful for:

money's

JOB IS TO

FURTHER MY

mission

IN LIFE.

- Amanda Frances

Giving money a role and a purpose is such a powerful tool. It's one thing to know you want money (who doesn't?) — it's another thing to know what you want it for. And it's most effective to know what role you desire for money to play in your life. There have been times when I needed money to support me in furthering my work, impact, and mission. Right now, I feel it's most important that money support me while I support my kids. And, of course, it still does the later as well. Whatever my mission, I expect money to support it.

One thing I want you to notice, is that we are now taking money out of a role of desperation & survival, and instead, asking money to help you thrive, truly live, and create a meaningful life. We are putting money in an entirely different position. If money has to do what you tell it and assume the role you give it, what would money be for in this phase of your life?

If money had already heard you, understood you and was ready to support you, what would you expect of money now?

If money were truly a neutral resource, with no mind of its own — what else would you have money do?

Say it with me: Money's job is to further my mission in life.

Week of ___/___/___

My desire for the week:

Monday:

Tuesday:

Wednesday:

Thursday:

This week's affirmation:

Money is a renewable resource. I can always make more.

Now, you write it:

Friday:

Saturday:

Sunday:

Ways I crushed it this week:

Week of ___/___/___

Things to do / Things to remember:

Things I'm releasing:

Things I'm calling in:

What I am grateful for:

Week of ___/___/___

My desire for the week:

Monday:

Tuesday:

Wednesday:

Thursday:

This week's affirmation:

I receive the solution, support, and guidance I desire this week. It is on its way to me.

Now, you write it:

Friday:

Saturday:

Sunday:

Ways I crushed it this week:

Week of ___/___/___

Things to do / Things to remember:

Things I'm releasing:

Things I'm calling in:

What I am grateful for:

Week of ___/___/___

My desire for the week:

Monday:

Tuesday:

Wednesday:

Thursday:

This week's affirmation:

I am where I am meant to be. This moment is the perfect launching pad for me.

Now, you write it:

Friday:

Saturday:

Sunday:

Ways I crushed it this week:

Week of ___/___/___

Things to do / Things to remember:

Things I'm releasing:

Things I'm calling in:

What I am grateful for:

Week of ___/___/___

My desire for the week:

Monday:

Tuesday:

Wednesday:

Thursday:

This week's affirmation:

People love to pay me.

Now, you write it:

Friday:

Saturday:

Sunday:

Ways I crushed it this week:

Week of ___/___/___

Things to do / Things to remember:

Things I'm releasing:

Things I'm calling in:

What I am grateful for:

SAY IT WITH ME:

IT'S SAFE TO PIVOT, GROW AND CHANGE DIRECTIONS. I ALLOW MYSELF TO EVOLVE.

@xoamandafrances

Life has phases, stages and seasons. We are going to each find ourselves wanting different things at different times. A business module, relationships dynamic or family schedule you create in one phase of life, might not fit in another phase of life. As we come to the end of the year, it's important to look at how we desire to let ourselves evolve.

No matter who won't get it, how it may be perceived, or what I am fearful of, how do I desire to evolve in this season of my life?

Where do I see myself going that I have possibly been afraid to admit to myself? What do I want that I maybe haven't said aloud?

If I could drum up or create any scenario, direction, mission or purpose for this next season of my life, what would I want?

Say it with me: It's safe to pivot, grow and change directions. I allow myself to evolve.

Week of ___/___/___

My desire for the week:

Monday:

Tuesday:

Wednesday:

Thursday:

This week's affirmation:

Wealth is how I live, how I be, how I think and how I dream.

Now, you write it:

Friday:

Saturday:

Sunday:

Ways I crushed it this week:

Week of ___/___/___

Things to do / Things to remember:

Things I'm releasing:

Things I'm calling in:

What I am grateful for:

Week of ___/___/___

My desire for the week:

Monday:

Tuesday:

Wednesday:

Thursday:

This week's affirmation:

I'm always working less and making more. Always.

Now, you write it:

Friday:

Saturday:

Sunday:

Ways I crushed it this week:

Week of ___/___/___

Things to do / Things to remember:

Things I'm releasing:

Things I'm calling in:

What I am grateful for:

Week of ___/___/___

My desire for the week:

Monday:

Tuesday:

Wednesday:

Thursday:

This week's affirmation:

I am the powerful creator of my life.

Now, you write it:

Friday:

Saturday:

Sunday:

Ways I crushed it this week:

Week of ___/___/___

Things to do / Things to remember:

Things I'm releasing:

Things I'm calling in:

What I am grateful for:

Week of ___/___/___

My desire for the week:

Monday:

Tuesday:

Wednesday:

Thursday:

This week's affirmation:

I thrive. No matter what, I thrive through it all.

Now, you write it:

Friday:

Saturday:

Sunday:

Ways I crushed it this week:

Week of ___/___/___

Things to do / Things to remember:

Things I'm releasing:

Things I'm calling in:

What I am grateful for:

Week of ___/___/___

My desire for the week:

Monday:

Tuesday:

Wednesday:

Thursday:

This week's affirmation:

I am a mother fucking money maker.

Now, you write it:

Friday:

Saturday:

Sunday:

Ways I crushed it this week:

Week of ___/___/___

Things to do / Things to remember:

Things I'm releasing:

Things I'm calling in:

What I am grateful for:

ABOUT THE AUTHOR...

Amanda Frances is a world-renowned thought leader on financial
empowerment for women.

Through her wildly popular digital courses, her best selling book, "Rich as F*ck," highly engaging online presence, her "And She Rises" podcast, and free daily content, meditations and trainings distributed across her private app and social media channels daily... she empowers women to design lives and businesses they are wildly obsessed with.

She has written for Forbes, Business Insider, Glamour, and Success Magazine.

She has been featured in Entrepreneur, Flaunt, US Weekly, OK! Magazine, Entertainment Tonight, Selling Sunset, Open House TV, The Messenger and others.

Combining her background in ministry and mental health counseling with practical advice and a deep knowledge of spiritual and energetic principles, Amanda isn't quite like any other "coach" you've encountered.

A true self-made woman, while putting herself through graduate school Amanda taught herself how to build her first website.

Thirteen years later, Amanda Frances Inc. is an eight-figure global brand serving clients and students in 85 countries and users in 99 countries and highly involved in philanthropic endeavors.

Amanda's mission has always been to get the power of money into the hands of good hearted women who are here to change the world. Today, she is actively doing so.

Amanda is from Sand Springs, Oklahoma and currently resides in Bel Air, California with her growing family.

Printed in Great Britain
by Amazon

42381525R00137